IMAGES of America
COLLEGE POINT

Victor Lederer
with the Poppenhusen Institute

ARCADIA

Copyright © 2004 by Victor Lederer and the Poppenhusen Institute
ISBN 0-7385-3529-X

First published 2004

Published by Arcadia Publishing,
an imprint of Tempus Publishing Inc.
Portsmouth NH, Charleston SC, Chicago,
San Francisco

Printed in Great Britain

Library of Congress Catalog Card Number: 2003116544

For all general information, contact Arcadia Publishing:
Telephone 843-853-2070
Fax 843-853-0044
E-mail sales@arcadiapublishing.com
For customer service and orders:
Toll-free 1-888-313-2665

Visit us on the Internet at www.arcadiapublishing.com

On the cover: the group shown was known as *Die Borse*, meaning "the exchange" in German. Composed of owners and managers of College Point's businesses, *Die Borse* met on Tuesday afternoons "to discuss the affairs of the village, the country, and the world." The setting is the conservatory behind the Eighth Street (now 117th Street) home of Adolph Erbsloh, the dark-bearded man standing just left of center. The gathering included August Schlesinger, seated third from right; Herman Funke Sr., seated at center; and Herman Funke Jr., seated third from left. The caption also notes stiffly that Charles Runk, seated at the left, was "not an old College Pointer."

This postcard, probably printed just before 1900, offers a surveyor's clear view of College Point from the southwest. The town's main buildings, including the Poppenhusen Institute, the Enterprise Rubber Works, as well as its churches and big houses, have been painstakingly drawn.

Contents

Acknowledgments 6

Introduction 7

1. The Early Days 9

2. Homes, Schools, and Churches 25

3. Factories and Businesses 49

4. Beer Gardens and Other Recreations 67

5. College Point Life 91

6. Serving the Community 105

7. The Poppenhusen Institute 117

ACKNOWLEDGMENTS

The Poppenhusen Institute thanks the following individuals and families who donated the photographs of early College Point that appear in this book: the Angenbroich family, Terry Brest, Henry Bangert, Charles Calitri, Larry Dwyer, Vic Coppola, Emily Fischbach, Christ Friess, the George Farrington family, the Hachtel family, the Koch family, Helen and John Korten, John Kubick, John Neumann, the Queens Borough Public Library, Doris and Marie Rausch, Wanda Sadowski, Tony Scatena, Louis Schnieder, Vincent Seyfried, Gertrude Von Sothen, Clarence Tyler, Mrs. Varmitag, the Al Vogt family, Homer White, Sue Wild, Minnie Woessner, Raymond Webber, Mr. and Mrs. Winter, and Donald Weidel. Thanks to all who have contributed to the archives of the Poppenhusen Institute over the years to preserve the history of College Point.

 I wish to thank two colleagues and friends, one old, one new: Josh Levine and Bob Levine, whose encouragement and advice early and throughout the process were vital in getting and keeping this book going. Thanks also to friends and colleagues at the Museum of the City of New York: Kassy Wilson, Eileen Morales, Barbara Elam, Phyllis Magidson, Bob Shamis, and Marguerite Lavin who gave me the chance to write and develop the organizational skills that are indispensable in assembling a photographic history. At the Poppenhusen Institute, thanks are owed to Faye Graham and Bill Schreiber who gave freely of their time and knowledge. This book would not exist without the help of my collaborator and friend Sue Brustmann, executive director of the institute. Special thanks are due to Bob Friedrich for his enthusiastic endorsement of this project and for his generosity in helping to answer the most difficult questions that arose along the way—Bob knows more about College Point than anyone ever has, or will. Thanks to my father for kindling my lifelong interest in urban photography; to my children, Paul and Karen, for their ideas, suggestions, and support. All my love and gratitude go to my wife, Elaine, for her support, patience, and faith in me—not always an easy cause.

—Victor Lederer

INTRODUCTION

College Point sits on a peninsula that looks west across Flushing Bay, an arm of the East River. Cut off from the rest of Queens by marshland and with few access roads, the neighborhood suffers from a reputation of being a backwater populated primarily by old families. College Point is indeed self-contained, preserving a quirky, small-town feel, as well as many remarkable Victorian structures. Yet, in addition to many families who have lived there for generations, College Point also counts as residents New York's recent immigrant groups, including Chinese, Koreans, and Colombians.

College Point's history begins with the Matinecock tribe, who sold land to early Dutch and English settlers and did not long survive the intrusion. The area's early European colonists included members of the Lawrence family. Their homestead, which stood at 14th Avenue and 129th Street, can be seen in the old photograph on page 13; the building was moved to Old Bethpage Restoration Village in 1970.

In 1835, Rev. William Augustus Muhlenberg, an Episcopal minister from Flushing, founded St. Paul's College for Seminarians, the short-lived institution for which College Point is named. Muhelnberg bought a large tract at the tip of the peninsula, today the site of MacNeil Park. Ground was broken the following year, but financial problems, exacerbated by the Panic of 1837, kept the school from reaching the scale its founder envisioned. By 1850, it had ceased operations.

A confluence of forces transformed mid-19th-century College Point from a riverside hamlet to a vibrant New York suburb. In search of sites to house Irish and German immigrants, developers scouted Brooklyn and Queens, where land was cheap and ferry and rail transportation in place, or at least feasible. The area's first intensive development, called Strattonport, was laid out in early 1851 from the present 23rd Avenue north to 15th Avenue, from 127th Street and west to the bay. The project's success led to the swift addition of more acreage to the north and along the waterfront; this was called Flammersburg. When in 1867 the three districts that remain the heart of the community were merged into a single town, College Point was the name that stuck.

Conrad Poppenhusen came to College Point in 1854. A hard working Hamburg native, Poppenhusen had arrived in the United States in 1843 to run a Brooklyn factory that manufactured whalebone products. Poppenhusen soon shifted the business to rubber. When vulcanizing was perfected later in the 1840s, he made a deal with its inventor Charles Goodyear for sole right to the process for two years. Needing space for a new factory, Poppenhusen settled on College Point, where he built the Enterprise Rubber Works. Poppenhusen's story sounds like

that of any shrewd entrepreneur of the day, but instead of the suspicion with which most mid-19th-century capitalists viewed their employees, Poppenhusen had advanced social ideas that set him far apart from his peers.

Poppenhusen made countless contributions to College Point, building decent houses for his factory workers to rent or buy, founding a savings and loan institution, and in 1876 chartering a train to carry his employees to the United States Centennial Exposition in Philadelphia. However, his most lasting gift was the endowment in 1868 of the remarkable institution that continues to serve College Point today. The landmark structure that houses the Poppenhusen Institute opened its doors in 1870, filling many functions for the town. In addition to the bank, it contained the first free kindergarten in the United States and two jail cells. While no longer a lockup, the Poppenhusen Institute offers classes, concerts, and other services to College Pointers; it also holds a splendid archive of College Point photographs, artifacts, and other historical treasures.

In the decades around the beginning of the 20th century, tourism was a major College Point industry. The town boasts spectacular East River views that led to its development as a weekend resort for working class New Yorkers. Witzel's Point View, Donnelly's, Freygang's Bay View, and dozens of smaller hotels and beer gardens flourished as armies of parched visitors arrived every summer Sunday by train and ferry in search of beer, food, pinochle, pick-up baseball, and cool breezes. College Point was known as the wettest New York suburb, but by 1925 Prohibition and the mobility provided by the automobile had put the beer garden resorts out of business. College Point still retained its riverside charm as late as 1937, when Mayor Fiorello La Guardia chose to summer in the old Chisholm Mansion, which stood in Mac Neil Park.

Conrad Poppenhusen's rubber products factory may once have been College Point's largest, but the town was home to other industries as well, including several breweries, metalworking companies, and silk ribbon mills. Metal fabricators maintained a significant presence in College Point until the late 20th century. Airplane manufacturers, common across Long Island until the 1970s, also operated in College Point, vivid evidence of which is the seaplane runway that extended from the EDO Aircraft factory shown on page 57.

College Point was absorbed by greater New York with the rest of Queens County in 1898. Yet the neighborhood that was once a separate town continues to maintain its distinct identity. College Point remains difficult to reach. No subways rumble beneath its streets, which are quiet and uncomfortably narrow for the big trucks that service its factories. College Point preserves an irregular, low-density, un-zoned appearance in which homes and businesses stand side by side. Unlike the bland, overbuilt look of some central Queens neighborhoods, College Point consists mostly of smaller buildings separated by alleyways and yards. For the student of architecture, it is a treasure trove of mid- to late-19th-century styles that richly rewards exploration, from the exquisite First Reformed Church to the mansard-roofed Victorian splendor of the Poppenhusen Institute. The best way to visit College Point is by car, starting at the institute and armed with a good map and guidebook.

One
THE EARLY DAYS

During the first half of the 19th century, the farmers and "proto-suburbanites" who lived in what is now College Point called the area Lawrence Neck after the area's oldest and most prominent land-owning family. Like most of the communities scattered along Long Island's rocky northern shore, Lawrence Neck enjoyed magnificent views of the East River and Long Island Sound: a single body of water that confusingly carries two names. These old photographs make the crowded city at the southern end of Manhattan seem a world away. Mostly taken in the 1860s through the 1880s, they show College Point after two waves of intensive mid-century real estate development that transformed farmland into a town but left the individual character and the physical beauty of the community's setting essentially unaltered.

One can almost feel the breeze in this idyllic East River view, which shows the beautiful setting that drew 19th century New Yorkers to College Point. Taken c. the beginning of the 20th century, the exact location of this photograph is not identified but probably looks north toward the Bronx shore from Point View Island, now Tallman's Island.

This run-down structure was St. Paul's College, the institution from which College Point got its name, not long before its demolition in 1900. Built in 1835 by Rev. William Augustus Muhlenberg, the building served as a seminary for only 15 years, after which it was used as both an elementary school and a summer hotel.

The caption on the back of this very old photograph of St. Paul's College buildings gives a date of 1868, which seems accurate based on the clothing worn by the unidentified people on the lawn. The buildings stood on the site of Herman Mac Neil Park, at the foot of the present 119th Street.

The caption on this 1893 photograph explains that the old college dormitories had been renovated as dwellings for families who spent the summer, the structures having grown too dilapidated for year-round use. The rural character of late-19th-century College Point is clear in this exquisite shot, taken from a steamboat pier next to the old school's site on the East River.

While serving as rector of St. George's Episcopal Church in nearby Flushing, Rev. William Augustus Muhlenberg, shown at the left, founded St. Paul's College for Seminarians, the institution from which College Point got its name. In 1848, Muhlenberg left Queens to become rector of a congregation in Manhattan, and St. Paul's went out of business.

First Avenue, shown in this undated early photo, is known today as 14th Avenue. It divided College Point between the factory owners and managers, who lived to the north in homes such as those shown here, and the workers, who lived in more modest dwellings to the south. The spire of the First Reformed Church can be seen up the street and to the right.

Louis Gaiser's Wine and Lager Bier Saloon, shown here in the late 19th century, occupied this modest structure on College Point Boulevard and 15th Avenue. The house still stands but has been altered so extensively that it is difficult to recognize.

The College Point peninsula was once called Lawrence Neck after a family of early settlers. This ancient photograph shows the old Lawrence house at 129th Street and 14th Avenue; it was moved in 1970 to the Old Bethpage Restoration Village. Two African American women stand at the small wing at the left; the people at the main entrance to the right are probably the Lawrences.

This tranquil 1907 postcard view, looking east, shows 14th Road. The steps to the Poppenhusen Institute are visible just to the right of center, although the building itself is mostly hidden by leaves. Two men chat on the sidewalk, and the trolley rumbles peacefully toward the camera.

Taken shortly after 1870, this excellent view shows Conrad Poppenhusen's Enterprise Rubber Works at center and the mansard-roofed Poppenhusen Institute at the right. The boats moored in Flushing Bay complete the picture of College Point as a compact New York suburb where people lived, worked, and found recreation.

College Point's large German-speaking community once had its own newspaper, the *Freie Presse*. This late-19th-century photograph shows the office the paper shared with a stationer and at least part of its staff. New York's large immigrant population has long supported a vigorous foreign-language press.

This photograph shows the wood-frame building that once stood at the southeast corner of 14th Road and 119th Street. The handwritten caption on the reverse gives a date of 1870, but the clothing worn by the couple in the storefront suggests the 1880s. In any case, the picture offers a fine glimpse of the Victorian architectural idiom of old College Point.

College Point was very much a water-oriented town: weekend visitors flocked to its beer gardens by ferry, and boating was a popular local recreation. Businesses sprang up to service boaters' needs, including Tyler and Mara, the dock-building firm that advertised its services with this photograph. The ferry *Enterprise* is visible in the background at the left.

E. W. Karker's sawmill, which stood near the bay at 110th Street between 14th Road and 15th Avenue, is shown in this superb image from the early 1870s. Karker's home, which still stands, can be seen between the chimney at the left and the mill.

17

Naturally, not all of College Point's businesses were large. In this photograph, baker George Hachtel's handsomely painted delivery wagon stands in front of his shop on 14th Road between 115th and 116th Streets. The mustachioed man leaning wearily against the tree could be Hachtel himself.

This wonderful image shows Fackelmann's saloon at 18th Avenue and 124th Street decked out magnificently in flags and bunting for some turn-of-the-20th-century event, perhaps the Fourth of July. Note the proud poses of the carefully dressed children at center right.

Christian P. Geidel's Meat Market was on 126th Street between 20th and 22nd Avenues. If the caption for this winter photograph is correct, the date of 1860 or 1862 makes it one of the earliest in the Poppenhusen Institute's collection. Geidel is presumably the white-bearded man standing in the doorway.

This small frame structure on the east side of College Point Boulevard, south of 23rd Avenue, was John Haefele's Hotel and Saloon. College Point was once famous for its weekend resorts, several of which were large and elaborate operations. However, this c. 1880 photograph shows that others were more modest establishments. The building still stands.

Elliott's Hardware occupied this wooden building on 14th Avenue. The open feel of College Point's streets, still evident today, and the quality of its Victorian domestic architecture are shown clearly in this photograph, as is the one-time small town's favorite occupation of porch lounging.

Over the years, College Point Boulevard has been called 13th Avenue and 122nd Street (and its southern extension was the Causeway), but the old road has always functioned as the community's main street. This photograph, shot on a wet and chilly day in the first years of the 20th century, looks south down the street from the intersection of 15th Avenue.

Nothing could better illustrate the open feel of College Point's streets or its isolation from the rest of Queens than this old postcard. It shows a trolley rounding the bend at the intersection of old 13th Street (now College Point Boulevard) and 25th Avenue at the southern end of town.

In 1885, the Chilton Paint Company built a factory on the site of Karker's sawmill, shown in the photograph at the bottom of page 17. His house, also visible in that picture, had been converted to the town's police headquarters by the time this postcard view was taken.

The old ferry dock and terminal building at the foot of 14th Avenue can be seen at the right of this interesting postcard view, taken from the deck of a ferryboat. The attractive building at center is Max Zehden's Casino and just to its left Riesenburger's Cozy Corner Hotel. Both are shown in photographs on page 76.

The railroad station in the center distance shows another form of transportation that has disappeared. The Northside Railroad serviced College Point until the 1930s; its station was at the eastern end of 18th Avenue. This image, which also shows a variety of businesses and passersby curiously watching the photographer, is a fine slice of suburban New York life in the last years of the 19th century.

This remarkable view, taken looking northeast from the roof of the Poppenhusen Institute, shows the growing town of College Point c. 1880. The most conspicuous structures in the view are the spire of the First Reformed Church, right of center, and the mansions on the rise in the distance. Note also the well-tended gardens behind the more modest homes across the street.

23

Robert Friedrich, College Point's hometown historian, took this photograph of Karl Butzbach's home and dairy shed on 126th Street, which stood untouched from Butzbach's death in 1936 until it was demolished in the mid-1950s. Friedrich notes on the back that the stable and shed contained hay, farming tools, harnesses, and a set of sleigh bells. The mysterious old house was a lingering remnant of a vanished way of life.

Two
Homes, Schools, and Churches

From c. 1850 until 1925, College Point was a microcosm of American society; the town was home to factories, shops, houses, and churches, and the capitalists, factory workers, and shop owners who lived, worked, and worshiped in them. The houses of the factory owners and managers were splendid, as these photographs show; those of the workers were small but generally decent. While College Point was named for the short-lived St. Paul's divinity school, it was also home, during the second half of the 19th century, to several military schools: Leseman's, Fuerst's, and Gerlach's academies, as well as the Bethlehem and Berachah orphan asylums. Education for College Point's children ranged from an ancient village schoolhouse to parochial institutions that served its sizable Catholic, Lutheran, and Dutch Reformed populations.

 The town continues to enjoy the presence of four churches that are a century or more old. The second Roman Catholic structure named for St. Fidelis on 124th Street was dedicated in 1895, replacing an 1856 wooden structure. In 1912, a brick St. John's Lutheran, off 22nd Avenue, was also built on the site of a wooden predecessor. The Union Evangelical Church, on 18th Avenue and 123rd Street, was opened in 1893; today its congregation is Korean American. Pride of place among College Point's houses of worship goes to the Dutch Reformed Church on 14th Avenue and 119th Street, a whitewashed clapboard jewel built in 1872 that would fit perfectly into a New England town square.

The handwritten caption on the back of this photograph reads: "This was the house of Conrad Poppenhusen, benefactor of College Point. It was demolished in the early 1900s." The house, which stood at 12th Avenue and 120th Street, had the typically ample grounds, handsome gardens, and wide porches that allowed College Point's business-owning class of the late 19th century to enjoy the East River breezes.

This early photograph shows one of College Point's oldest mansions, the H. A. Schleicher house. An extraordinary survivor, the Schleicher house still stands on its own island at the center of the intersection of 13th Avenue and 123rd Streets. It became the Grand View Hotel, as shown in the photographs on page 85, and has since been broken into apartments.

A business associate of Conrad Poppenhusen's, August Schlesinger owned this fine house on 12th Avenue near 116th Street. Note the large porch, the beautiful striped awnings, and horse and wagon at the foot of the steps. Schlesinger is the self-assured man with the white beard seated third from the right in the cover photograph.

Adolf Poppenhusen, Conrad's son, owned this mansion, which stood at 9th Road and 120th Street. Members of the Poppenhusen family had to mortgage their homes to raise money when their investment in the Long Island Railroad went bad in the late 1870s. This house must have been one such property, although the children playing on the lawn appear untroubled.

27

The Boker house, shown here, had a fascinating history. Built in the mid-1850s by Friedrich Koenig, a partner of Conrad Poppenhusen, it was later occupied by the Hammacher family and was successively John Jocker's Grandview Hotel, Gerlach's Academy for Boys, the clubhouse of the College Point Club, and a boarding house favored by actors who worked in a Flushing film studio in the 1920s. The Boker house was demolished in 2004.

The flags, the uniformed little boys carrying toy rifles, and most of all the presence of Civil War veterans on the steps of the Boker house make it clear that some patriotic event is being celebrated. The house was likely in its incarnation as the College Point Club in this turn-of-the-20th-century photograph.

This pretty house at 13–11 123rd Street was owned by Jacob Salathe, probably the proud man at the top of the steps. Salathe was superintendent of the Openhym Silk Mill in College Point. Note the exquisite craftsmanship of the construction and the care with which the building was maintained. The house still stands but has been altered considerably.

The residence of Francis Clair enjoyed a magnificent site on Poppenhusen Avenue, near what is today the eastern end of Mac Neil Park. This *c.* 1900 photograph highlights the stupendous view it commanded across the East River. The house, with a pavilion built to take advantage of views and breezes, is a handsome example of Renaissance Revival design.

The Chisholm mansion occupied a dramatic riverside site at the northwestern tip of College Point. Mayor Fiorello La Guardia used it as his summer residence in 1937. In 1941, parks commissioner Robert Moses had it torn down when the land on which it stood was named Mac Neil Park after Herman Mac Neil, the famous sculptor who once lived nearby.

This attractive house and elaborate garden on 14th Avenue belonged to businessman John W. Rapp, whose ornamental metal works and the extraordinary calliope wagon that advertised it are shown on page 52.

The clean lines and straightforward domestic architecture of the Vogt house, shown in this c. 1880 photograph, form a strong contrast with the large and elaborate mansions of the preceding images. Built in the mid-1850s, it still stands at 13–17 123rd Street and is easily recognizable from this photograph. Members of the Vogt family continue to occupy the house.

This photograph, taken in July 1926, shows the ruined mansion of Capt. John Graham not long before its demolition. Many legends attached themselves to shipping magnate Graham and his house, including one noted on the back of this photograph, stating that slaves were held in cells in the basement. The prosaic likelihood is that these were storage bins for food.

Known as "the Eighteen," these houses were built by Conrad Poppenhusen's India Rubber Comb Company. Although they provided decent housing for his workers, they were far less substantial than the brick houses the Steinways built for employees at their Astoria piano factory. The Eighteen houses stood for approximately 50 years—from 1860 to 1910—across 15th Avenue from the factory.

These attached brick homes went up *c.* 1920 on the block between 14th and 15th Avenues where the Eighteen houses once stood. They resemble many other Queens, Brooklyn, and Bronx residences of the era.

The streets of College Point are blessed with the presence of many handsome middle-class Victorian dwellings such as this one. Falling between the grandeur of the mansions and the workers' modest homes, houses such as this can be found in abundance throughout the neighborhood. This one still stands on 114th Street between 14th Road and 14th Avenue.

These are good examples of the kind of superior architecture and uncrowded layout that make the College Point streetscape so interesting. Much altered, these twin frame houses at 14–22 and 14–24 114th Street still stand.

College Point was home to a number of private schools in the last few decades of the 19th century. One was Leseman's Academy on 119th Street, where young men between 6 and 16 were enrolled as cadets, dressed in uniforms, classically schooled, and taught to ride and shoot. Adolph von Uechtritz, above, was its owner and director in the 1870s and 1880s.

This undated photograph, taken before the beginning of the 20th century, shows the class of Agnes Lawlor, teacher of English and music at the old Public School No. 27. Lawlor stands in front of the blackboard. To her right and wearing a skullcap is Henry Delamain, the school principal. The new school building opened in 1899, providing an approximate date for this picture.

This charming picture, apparently from the same period as the one at the top of the page, shows the first grade class of Mrs. Pratt. Principal Delamain stands in his skullcap to her left. Note the schedule for the day, written on the blackboard behind the teacher, and the way the children have folded their hands uncomfortably behind their backs for the photograph.

35

When the old Public School No. 28 on 115th Street closed and the new Public School No. 27 on 14th Avenue and College Point Boulevard opened, the children marched to the new building. The procession is captured here, although not the identity of the young man in a gray derby at the right.

This c. 1910 photograph shows the boys of another College Point educational institution: the Bethlehem Orphan Asylum on 112th Street between 14th Avenue and 14th Road. The boys on the right may be carrying rifles as evidence of their quasi-military discipline or their patriotism.

The inscription on the back of this curious studio photograph identifies the young man as "Sully" Uechtritz, instructor at Leseman's Academy in College Point. Putting aside questions about his unusual pose and the identity of the older woman in the rowboat, it is difficult not to wonder how a playful Sully got along with the intense-looking Adolph von Uechtritz, whose portrait is on page 34.

With most of its photographs dating back to the late 19th and early 20th centuries, the contents of the Poppenhusen Institute's archives capture a long-lost world. Yet, a look at the January 1941 graduating class of Public School No. 129 also reveals a vanished era, when

graduating sixth-graders dressed in dark suits and matching white gowns to mark the momentous day.

Unquestionably one of College Point's finest and most impeccably maintained architectural treasures, the exquisite First Reformed Church at 114th Street and 119th Avenue was dedicated in 1873. The equally beautiful chapel that was built immediately to the east several years later does not appear in this image, allowing a close dating to the mid-1870s. The church was built largely with funds donated by Conrad Poppenhusen; the congregation originally met in the Poppenhusen Institute.

This attractive 1858 wood-frame church at 22nd Avenue and 123rd Street was the original home of St. John's Lutheran parish. It was demolished in 1912 and replaced by the present brick structure, which, at nearly a century old, is among the newest church buildings in College Point.

Built in 1893 as the Union Evangelical Church, this building at 18th Avenue and 123rd Street currently serves a Korean American congregation as the New York Mission Church. While its strong form is instantly recognizable, the fine woodwork that decorated the church's facade has been removed.

Here is St. John's Lutheran Church on July 22, 1907, decorated handsomely for the celebration of the congregation's 50th anniversary. The caption on the back says the steeple was added in 1879.

The unidentified minister, or choirmaster, at the lower left, and the members of the choir of St. John's are shown standing on the steps of the congregation's second church in this group portrait c. 1920.

43

This ancient image, dating to the mid-1870s, shows the first St. Fidelis Roman Catholic Church, built in 1856 on 124th Street between 14th and 15th Avenues. Work to widen 124th Street was in progress when this picture was taken.

Father Joseph Huber, Austrian by birth, came to College Point in 1856 to found the town's first Catholic parish. Working energetically to meet the spiritual needs of the town's burgeoning Catholic population, Father Huber oversaw the construction of the church shown on the opposite page, dedicated to St. Fidelis of Sigmaringen. Huber died in 1889 and was buried in the churchyard.

So many German and Irish Catholics moved to College Point throughout the second half of the 19th century that the old St. Fidelis quickly became inadequate. On September 23, 1894, the cornerstone for the second St. Fidelis was laid in the ceremony that is recorded here. The old church was left standing while its replacement went up.

The extraordinary building to the right of old St. Fidelis is the Dominican convent at 14th Avenue and 124th Street. It is home to the nuns who teach at the St. Agnes Parochial School. Although the superb wooden shingling of the convent has been replaced with dull yellow brick, and the Gothic finials over the dormers are gone, the old building's strong form continues to enliven the streetscape.

This picture c. the early 20th century shows the same scene as the photograph at the top of this page but with the second, brick-built St. Fidelis church having replaced the original wooden structure.

The caption on the back of this photograph shot on the steps of St. Fidelis gives May 30, 1910, as its date. The boys are described as the St. Fidelis Cadets Drum and Fife Corps, and the occasion shown here is a reception by the College Point Club for Civil War veterans. The corps acted as honor guard. Compare their pose with that of the Bethlehem Orphan Asylum children on page 36.

Serious, but otherwise unknown, this group is identified only as being associated with St. Fidelis, c. 1900. Note the faraway look on the face of the nun at the left.

47

THE INDIA RUBBER COMB CO.

Factory, Enterprise Works, College Point, L. I.

Nos. 9, 11, & 13 Mercer Street, New York.

MANUFACTURERS OF

GOODYEAR'S HARD RUBBER GOODS.

COMBS OF ALL DESCRIPTIONS,

...inges, Drinking Flasks, Whipsockets, Inkstands, Oilers, Thimbles, Doctor Plates, Doll Heads, Martingale Rings, Tum... ...s, Funnels, Dice Cups, Rulers, Scoops, Soap Trays, Hard Rubber Covered Rolls for Paper Machinery, Castor Roll... ...pkin Rings, Whip Handles, Salad Spoons and Forks, Gas Faucets, Mustard Spoons... Photographic Goods, Baths, Dippers, Pans, Telegraphic Goods, Key Knobs, Switch Handles, Insulato... ...rgical Goods, Trusses, Pessaries, Stethoscopes.

HARD RUBBER SHEET, ROD AND TUBING.

Mr. Poppenhusen's Factory

This wonderful advertisement probably dates from the mid-1850s, when Conrad Poppenhusen had exclusive rights to Charles Goodyear's vulcanizing process, by which rubber is hardened. Note, in addition to the extraordinary list of products, the careful detail with which "Mr. Poppenhusen's Factory" is illustrated and how it is proudly referred to as the "Enterprise Works, College Point, L. I."

Three
Factories and Businesses

College Point's largest employer for many years was Conrad Poppenhusen's Enterprise Rubber Works. Originally called Meyer and Poppenhusen, the name of the firm that owned the factory underwent several changes and was finally the American Hard Rubber Company when it moved to Butler, New Jersey, in the 1930s. However, a number of other good-sized industrial plants also operated in the town, including Kleinert's rubber works, Funke's silk mill, and a Chilton Paint Company factory, which burned spectacularly to the ground in May 1887. Many large metalworking firms settled in College Point too, including John Rapp's Ornamental Metal Works, shown on page 52. Another important College Point metal fabricator of the 20th century was Traulsen Company, which is still well known for its high-end refrigerators for restaurants and homes. Aircraft manufacturers also had a long and important presence; Sikorsky Aircraft, LWF Engineering, and EDO Aircraft all ran large operations in the town between 1920 and 1970. These were the years when aviation was one of the largest industries in Queens and Long Island. And, of course, College Point had its share of the small merchants and other service businesses found in any town. Luckily, the archives of the Poppenhusen Institute contains many photographs of charming old places, such as Emil Riesenburger's clothing store, Familton's Victrola dealership, Martini's fish store, and Bruehl's and Koch's butcher shops, as well as the nameless printer and blacksmith on page 55; they are all superb images that preserve the look of old College Point.

By c. 1920, when unidentified members of the management team posed for this group portrait, Poppenhusen's old rubber business was known as the American Hard Rubber Company. The handwritten caption above the photograph simply reads, "A. H. R. Co."

This c. 1900 postcard view of the Enterprise Rubber Works is brought to life and rendered mysterious by the man seated on the curb at the lower left; perhaps he was placed by the photographer to show the scale of the factory. The identity of William W. Weitling, whose home is pictured in the inset at the upper right, is not known, though he may have been the factory superintendent.

Like many photographs of College Point shot from Flushing Bay, this view gives a clear sense of the town as a self-contained community. To the left are houses; the Chilton Paint factory, the building with the tallest smokestack, is at center. Beyond the Enterprise Works and just right of center the roof of the Poppenhusen Institute can be seen. Completing the picture are the tidy sailboats moored in the bay.

The caption on the back of this superb group shot identifies the men as workers at the American Hard Rubber Company. Evidently on their lunch break, they seem as calm and cheerful as the managers on page 50 could want. The bottle of beer held by the man second from the left dates the photograph to the years just before Prohibition in 1919.

This photograph, one of the greatest in the collection of the Poppenhusen Institute, shows the fantastic horse-drawn wagon that advertised John W. Rapp's ornamental metal works in front of the factory. The wagon, which contained a calliope to attract attention as well as to entertain, was covered with samples of the fine castings produced at the factory. Rapp's home is shown on page 30.

Nineteenth-century College Point was home to at least three silk ribbon mills: Openhym's, Samuel Kunz's on 121st Street south of 22nd Avenue, and Herman Funke's Rhenania mill (named for the Rhine river) at 15th Avenue and 119th Street, shown in this 1872 view. Funke is seated at the head of the table in the cover photograph.

52

I. B. Kleinert's Rubber Company, which operated in a former Poppenhusen factory at 20th Avenue and 127th Street near the edge of town, manufactured rubber items that went into a variety of garments, from dresses to earmuffs. This beautiful late-19th-century shot shows two of the proud "firemen" who kept the Kleinert furnaces well stoked. The factory buildings still stand, housing a private storage facility and other businesses.

A member of an old College Point family, Robert F. Tyler worked at the Kleinert factory for 42 years. Starting as a fireman, like the men in the photograph at the top of the page, he eventually became the plant's chief engineer. He is shown *c.* 1920 in this powerful image, with a turbine at his back and a copy of *National Engineer* close-by.

53

The Chilton paint factory enjoys at a dramatic view of Flushing Bay from its site at the western end of 15th Avenue. This postcard view from the early 1900s shows the second Chilton plant, built after the original one was destroyed by fire, with a group of cheerful local boys, their trouser legs rolled, enjoying the beach.

J. F. Wieners Jr., a prolific and talented local photographer, took several pictures of the hellish aftermath of the fire that destroyed the original Chilton paint factory in May 1887. Only the smokestack, which was incorporated into the replacement structure, remained. That building, without the chimney, still stands. Note the metal equipment parts strewn across the ground in this spectral composition.

As an independent town, old College Point was home to businesses of all sizes and descriptions. This lovely portrait from the early 20th century shows an unidentified workshop, most likely a blacksmith's, artfully draped with bunting.

Based on the clothing, this is an older photograph than the one at the top of the page. Captured here are the men and boys who worked in an unidentified College Point print shop. It may well have been that of the *Freie Presse*, shown on page 15.

Long Island, including Brooklyn and Queens (the New York City boroughs that occupy its western end), is one of the cradles of aviation. College Point was once home to several important aircraft manufacturers, including LWF Engineering, which employed about 500 workers to build fighters. The photographs above and below show LWF's shop and were taken for the 1919 *Aircraft Yearbook*.

The presence of two female workers at the right makes this picture taken inside the LWF plant unusually interesting because it shows that women of the early 20th century were employed in heavy industry, not just garment manufacturing.

The Long Island shore was once studded with wooden runways used by seaplanes for takeoff. This c. 1950 photograph shows the one (apparently used by Charles Lindbergh) that extended into the East River from EDO Aircraft Corporation's College Point plant. Named for its founder Earl Dodge Osborne, EDO once specialized in seaplane pontoons and floats; the firm remains an important defense contractor.

Igor Sikorsky, another giant of early aviation, built planes and parts in this plant on the bay at 119th Street, facing the end of 18th Avenue. The building, shown in this photograph from June 1928, is now a beverage distribution facility but has been altered so extensively that it is unrecognizable.

The handwritten caption on the back of this c. 1920 photograph of Bruehl's butcher shop notes that the store stood on old 13th Street—"now College Point Boulevard"—and that the "family lived above the store." This was a common arrangement among smaller retailers of the day.

Martini's fish market was on old 2nd Avenue just west of 7th Street, currently 14th Road and 116th Street. This charming photograph from the 1890s reflects a very different time, when fishmongers wore business attire under their aprons and dogs were not unwelcome in food markets.

This photograph, taken *c.* 1910, shows the staff and two horse-drawn delivery wagons of Ferdinand Koch's butcher shop. The store occupied a fine old house on the southwest corner of College Point Boulevard and 22nd Avenue, which remains today, though altered extensively. The figure at the left in both this photograph and the one at the bottom of the page are the same man, probably Koch himself.

The sign displaying the phone number of Ferdinand Koch's butcher shop on the side of his beautiful delivery truck in this *c.* 1920 family business portrait offers potent evidence of the twin revolutions in transportation and communication that had taken place since the top image was shot.

59

PAGE 20 • COLLEGE POINT TRIBUNE • JUNE 25, 1976

4 generations since 1868 of Farringtons in College Point

Horse — 1899

Wooden Building — 1931

Brick Building — 1941

This page is brought to you as a community service by
Farrington's Service Station & Garage
126-06 15 Ave., College Pt. 359-9601

The Farrington family provides the most remarkable example of continuity in College Point. Named for their original trade, which involved shoeing and care of horses, the first Farringtons came to Queens in the 1640s. Their descendants still own the farrier's shop, which became a service station at 15th Avenue and 126th Street, shown in this 1941 advertisement.

60

Although College Point enjoys one of the finest waterside settings of any New York neighborhood, for a variety of reasons boating is no longer one of the town's major pastimes. This photograph of the College Point Boat Corporation's yard is one of many in the Poppenhusen Institute's archives that testifies to the beauty of that form of recreation, now almost lost.

The handwritten caption for this richly detailed photograph describes G. M. Familton's on College Point Boulevard as having sold "Victrolas and other such music boxes." Close inspection reveals people posing in all three second-story windows, signs advertising the "Friendship Talking Machine Co., G. M. Familton, Prop." on the store's display windows, and Kish's ice cream shop to the right.

The magnificent structure that housed Levinger's brewery at 14th Road and 120th Street resembled a Venetian *palazzo*. This image, shot *c.* 1870 by local photographer Frank Hunold, is testimony to a time when industrial buildings—even breweries—were designed with an eye

to aesthetics as well as function. The brewery was supposedly operating illegally as a distillery when it burned down in the 1920s.

Emil Riesenburger owned both this clothing store on College Point Boulevard and 18th Avenue and the hotel across from the ferry landing at 14th Avenue and 110th Street, shown on page 76. The tall woman in the doorway is identified as Margaret Gick Creamer.

Charles Johnston's hardware store, shown in this fine image from the first decade of the 20th century, stood at 15th Avenue and College Point Boulevard, just up the street from Riesenburger's. Shop windows at this time were uniformly and delightfully cluttered.

Karsch's brewery, shown in this image from the 1890s, was just one of several in College Point, one of the heaviest beer consuming communities in the northeast.

Both Point View Island, College Point's largest beer garden resort, and Witzel's Hotel, shown in this 1907 image, were owned by Joseph Witzel. The hotel, which stood at 14th Road and 119th Street, was nowhere near the size of Point View Island; however it had its own popular dancing pavilion. First opened in 1871, the establishment survived as Flessel's restaurant and bowling alley until 1999.

Four
BEER GARDENS AND OTHER RECREATIONS

From 1870 to 1920, College Point was a favorite weekend resort for working New Yorkers. While no precise data is available, the town's turn-of-the-20th-century population of about 10,000 regularly doubled and may even have tripled on summer weekends as hordes of visitors arrived by train and ferry. Some found overnight accommodation in the town's hotels and rooming houses, but for most the trip to College Point was a Sunday outing; Sunday being, at the time, the only full day off workers enjoyed. What drew them were the town's East River beaches, breezes, and beer garden resorts. The larger ones were sprawling camp-like operations where guests were fed, watered, and given plenty of room to entertain themselves with cards, baseball, horseshoes, music, dancing, and other activities. The largest, Joseph Witzel's 27-acre Point View Island, today near the site of a large municipal sewage treatment plant, had its own pier where customers landed by ferry and barge. According to one source, on September 4, 1903, Witzel's served untold quantities of food and beer to an incredible 16,000 visitors. The largest resort after Witzel's was Donnelly's. Other hotels and resorts included Freygang's Bay View, Zehden's Pavilion, John Angenbroich's Hotel and Summer Garden, and the Grand View, which occupied the old Schleicher mansion before taking over the Boker House, pictures of which appear on page 28. The hotels and resorts were also popular for meetings of groups: from local Democratic and Republican organizations conducting business to cycling and bowling clubs, marching bands, and loosely organized men's associations with the sole purpose of running picnics and other recreations. The resorts' heyday ended with Prohibition and the advent of the automobile, which allowed Americans far greater latitude in choosing weekend destinations. This astonishing sequence of images reveals what is surely the most colorful piece of College Point's history.

This 1898 advertisement for Point View Island shows what attracted overheated Manhattanites to College Point on summer weekends in the days before air conditioning and automobiles. Overnight accommodations are not listed at the lower right because most visitors came just for the day on Sunday. The advertisement also shows the ferry dock. Today, the site is occupied by a municipal sewage treatment plant.

This postcard image, showing the driveway into Witzel's Point View, was taken in 1907 by local photographer Fred Hettling. The barn-like buildings and open layout of the resort are strongly reminiscent of a summer camp, a later cultural institution that also served the purpose of getting people out of the hot city.

WITZEL'S POINT VIEW, COLLEGE POINT, N.Y.

Another postcard view taken by Fred Hettling shows the ferry dock, at the left, which countless guests of Witzel's Point View crossed. One of College Point's beaches is visible in the foreground; the Bronx shore can be seen in the distance, at the left, and the glorious waterside setting that made the town so appealing to weekend visitors is fully revealed.

Knoch's Bathing Pavilion at Witzel's Point View, College Point, N. Y.

This postcard shows "Knoch's Bathing Pavilion at Witzel's Point View, College Point, N.Y." The wooden structure probably contained changing rooms for the guests. Note also the gondola fully afloat just a few feet from shore. Similar to Koch's swings shown on page 71, Knoch's bathing pavilion must have been a concession leased out by the Witzels.

69

In its heyday, the Point View was so popular that guests used every available form of transportation to reach it. This postcard shows the Iron Steamboat Company's ferry *Sirius* at the dock shown in the postcard on page 69 and in the advertisement on page 68. When demand peaked, barges were chartered. Others arrived by train, trolley, and coach, such as the Tally-Ho, shown on page 79.

The bristling mustaches and fierce poses of some Point View staff suggest that they doubled as bouncers. The caption on the back identifies the second and fourth men from the left in the front row as Henry Graf and Otto Muhlenbrink and the one at the left in the back row as Andy Rheinhardt. (Courtesy of the Queens Borough Public Library, Long Island Division, Illustrations Collection, College Point.)

Koch's Swings & Hat Box
at Witzel's Point View,
College Point, L. I.

This interesting postcard shows guests and staff gathered in front of the shooting gallery, and the mysteriously named hat box and Koch's swings at Point View. Close inspection reveals that the hat box was merely a hat and coat check. It is uncertain why the swings were called "Koch's." Perhaps they were a concession owned by someone with that name, which is common in College Point.

Emil Witzel, the son of Joseph, stands before the splendid Pavilion Bar at Point View. Note at the left the bartender with a beer keg on his shoulder. (Courtesy of the Queens Borough Public Library, Long Island Division, Illustrations Collection, College Point.)

Ball Ground at Donnelly's Grove,
College Point, L. I.

Donnelly's Grove, College Point's second largest resort, faced north on the East River from 14th Avenue between 114th and 115th Streets. This 1912 postcard shows some surprisingly well-dressed guests enjoying themselves on the ball field, with the structure that contained the dining room, bar, and a dancing pavilion in the background. The message written on the reverse is in German.

Donnelly's was popular as a meeting place for large organizations, including political parties. It was there that Teddy Roosevelt announced his candidacy for the New York State Assembly. The traces of snow at the entrance to Donnelly's mean that this photograph was taken out of season.

Third Grand Annual Ball...

MUSIC BY PROFESSOR BOLLER.

of the

Wine, Liquor and Beer Dealers' Association,

Third Ward, Borough of Queens,

At **Donnelly's Hall,** College Point, N. Y.

LADIES FREE

On **Easter Monday,** April 8th, 1901.

TICKETS, - Admitting One, 50 - CENTS.

Committee of Arrangements:

Thomas Farrell, Chairman, Chas. Brinkman, Sec'y., F. X. Duer, Treas., Max Meyer,
Ed. McCormack, J. F. Haubeil, Frank Winters, Geo. Weber, Frank Rolf,
Henry L. Partenfelder, John S. Corey.

Shown on this page are tickets to two affairs held at Donnelly's. This one is for the third annual grand ball of the Wine, Liquor, and Beer Dealers' Association of the Third Ward, Borough of Queens, on April 8, 1901. The cost to those invited was 50¢, with ladies attending free. Music was provided by "Professor" Boller; apparently professor was a title commonly assumed by band leaders of the era.

1103 FOR GOVERNOR OF THE STATE OF NEW YORK—A DEMOCRAT! 1103

SECOND ANNUAL OUTING

OF THE......

United Democratic Clubs

...of the Borough of Queens...

TO **DONNELLY'S BOULEVARD GROVE,** COLLEGE POINT, L. I.,

Special Trolley Cars will leave Monitor Square, Jackson Ave. and Third St., Hunter's Point, at 12.30 p. m. and 92d St. Ferry, Astoria, at 1 p. m. sharp.

ℭ .tors: { Hon. JAMES W. RIDGWAY,
 Hon. MAURICE F. HOLAHAN,
...of Tammany Hall.

Hon. JOHN P. MADDEN will preside.

Tuesday, Aug. 30th, '98

MUSIC BY PROF. FRANK PAUL'S MILITARY BAND, 40 PIECES.

TICKETS, - - $2.50.

DINNER

Just as appealing as the above ticket is this invitation to the outing at Donnelly's on August 30, 1898, of the United Democratic Clubs of the Borough of Queens. Special trolley service from Long Island City was provided, and the Democrats were entertained by another musical professor—Frank Paul—and his 40-piece military band.

> # GRAND ANNUAL
> ## Complimentary and Invitation Pic=nic
> ### —OF THE—
> # HOO-WAN-NE-KA CLUB
> ### OF FLUSHING,
> ——TO BE HELD AT——
> **FREYGANG'S BAY VIEW PARK, COLLEGE POINT, L. I.**
>
> ### Wednesday Eve., July 21, 1897.
>
> Music by Kehoe's Orchestra. Special Invitation extended to all ladies.
>
> **COMMITTEE OF ARRANGEMENTS:**
>
> John J. O'Connor, John J. Halleran, Jr., James L. McElroy, John J. Hanlon,
> Thomas A. Healy, James A. Walsh, Thomas Cleary, Joseph Graven,
> Michael E. Farrel, Thomas P. Jermyn, Bernard E. McElroy.
>
> Positively no charge in connection with this invitation. The committee reserve the right to eject objectionable persons.

Although the purpose of the Hoo-Wan-Ne-Ka Club of Flushing is unknown, this invitation to the free picnic it held on a summer evening long ago is charming and funny. It includes a "Special Invitation extended to all ladies" and a warning to potential "objectionable persons."

This photograph, dated October 20, 1894, shows the entrance to Freygang's Bay View Hotel, where the Hoo-Wan-Ne-Ka Club held its picnic. The fine-looking group in front is described as "Freygang's Guest Guard with band." Note also the excellent painted signs over the door.

John Angenbroich's Riverside Hotel occupied a building that still stands on 119th Street, overlooking Flushing Bay. The remarkable signs that decorated its exterior are worth a second look. This image, one of the clearest and most beautiful in the Poppenhusen Institute's photographic archive, speaks eloquently about the character of old College Point.

This c. 1900 postcard view shows another entrance to Angenbroich's hotel.

Riesenburger's Cozy Corner Hotel occupied this handsome wooden structure at the southeast corner of 14th Avenue and 110th Street. Its highly visible location, just across from the old ferry terminal, must have been good for business.

Max Zehden's Casino operated next to the ferry landing on 14th Avenue and was yet another of College Point's popular summer refuges. The attractive restaurant was destroyed by fire in the summer of 1908. Similar to Riesenburger's in the photograph above—and many other homes and hotels in town—Zehden's had a beautiful porch.

The heart of the Poppenhusen Institute's photograph collection are these astonishing images of men's associations, formed for the sole purpose of drinking beer outdoors on summer Sundays. This 1905 photograph shows the Big Toe Association gathered near Public School No. 27 on College Point Boulevard, then called 13th Street. The group's ponderous whimsy of the group's name is not explained.

Taken at Witzel's Point View Island *c.* 1900, this group is drinking beer and playing "an enjoyable game of German pinochle," according to the caption on the back. A number of young boys are being taught the rituals of male society.

The Annual Hot Corn Outing of the John C. Haefele Association of College Point was held on August 8, 1909, and captured for a grateful posterity by the local photographer Jacob F. Wieners Jr.

The handwritten caption on the back of this classic image, probably shot at Point View, identifies it only as "a less formal portrait of a select group." The ribbons in the lapels of some of the men probably identified the organization that sponsored the outing.

The William C. Flyder Association's Tally-Ho Party of September 27, 1908, was recorded in this marvelous photograph. The group's use of the large horse-drawn wagon must have made the choice of a name for the outing quite easy.

Another pleasant variation on the beer garden picnic is shown in this image, commemorating the Hudson-Fulton Association of College Point's charter of the *Commodore* for its 1909 outing. As with the Haefele Association's picnic on page 78, Jacob Wieners Jr. was the photographer.

Much of College Point's male socializing also took place indoors. This image shows Louis Gaiser's College Point Boulevard saloon (also pictured on page 13) c. 1901. The photograph behind the bar appears to be of Pres. William McKinley, who had been assassinated that year. Black ribbons decorate his portrait.

This undated photograph shows what appears to be the owner, Mrs. Schmidt, and two cheerful patrons in the doorway of J. Schmidt's cafe, the location of which is unknown. The meaning of the gesture of the man with the pipe is unclear.

The following three photographs provide a close look at the life and work of a College Point saloonkeeper during the early 20th century. This first undated photograph shows a young and lonely looking Charles Greener behind the bar of his 15th Avenue watering hole.

By July 6, 1911, when the industrious Jacob Wieners Jr. took this group portrait of the Charles Greener Association of College Point's first annual outing, Greener had at least 20 friends who were happy to spend the day drinking beer and playing baseball with him. Greener is wearing the white cap at the center of the front row.

Finally, this image captures an older and wider Greener outside his saloon with his wife, Kunegunda, his young daughter Gwendolyn, and two unidentified patrons (one female) at his side. If Greener's own appearance were not sufficient to date this photograph as the latest of the three images, the presence of the car at the bottom left would be.

82

Before radio and television gave people excuses to stay home, common interests created social interaction and entertainment. Not all of College Point's associations were devoted to drinking; love of music was the glue for others. Here, the Hillside Drum, Fife, and Bugle Corps of College Point is shown splendidly arrayed, perhaps for a parade.

Gathered here at Joseph Witzel's Hotel (not the Point View) on October 21, 1892, are the members of the Lewis and Fowler Outing Club. Although this group's purpose is less clearly defined than that of the one pictured at the top of the page, at least the members shown here, carrying a violin, a trumpet, and a harp, planned to play.

83

Jacob Wieners Jr. took this fine 1908 photograph of the College Point Mannerchor. The word *Mannerchor* is German for "men's choir," suggesting that much was sung in the native language of many of its members. Its 69 choristers were of a wide age range and united by their love of singing. Note also the marvelous variety of their mustaches. The Mannerchor, which survived until 2004, was one of several male choruses in town.

The ubiquitous Wieners Jr. also photographed the members of the Puck Bowling Club Team in this *c.* 1905 group portrait. Note the balls and pins arranged artfully at their feet, and on their heads the handsome club cap, inscribed "Puck BC."

Both this picture and the nearly identical one at the bottom of the page are portraits of cycling clubs taken on the steps of the Grand View Hotel, which once occupied the Schleicher House. This remarkable old house, easily recognizable in both pictures, still stands in the intersection of 13th Avenue and 123rd Street. The group in this undated image is unidentified.

This photograph is undated as well, but the group pictured is the League of American Wheelmen. Jacob Wieners Jr. is the photographer. (Courtesy of the Queens Borough Public Library, Long Island Division, Robert C. Friedrich Collection, College Point.)

85

Although many decades have passed since College Point was a true waterfront community, the town's East River beaches were once famous and popular. This 1897 image shows Tyler's Bath House at the end of 14th Avenue. (Courtesy of the Queens Borough Public Library, Long Island Division, Illustrations Collection, College Point.)

Beaches need lifeguards; College Point had the Kerosene Dock Life-Guards, captured in this group portrait from the summer of 1935. The image shows how late into the 20th century College Point's beaches were in use.

Lifeguards need their fun too, as shown in this photograph of the Kerosene Dock Life Guards' dinner on October 16, 1937, after the season's end. Many of the men in this picture can be seen in the beach photograph from two years earlier on page 86. Interestingly, College Point's social patterns remained much as they had been 40 years before.

The Poppenhusen's archive contains some splendid images of local teams. This one shows the College Point Indians football team, photographed *c.* 1900 outside the Grand View Hotel. The caption on the back identifies the man in the derby at the right end of the third row as Henry Rauhl, who appears to have been the Indians' coach and manager.

The American Hard Rubber Company sponsored a number of teams, some of which competed with considerable success. This shows the AHR Aces basketball team, who, as the handwritten caption at bottom says, were "Long Island Champions 1921–1922." Note the team's sharp two-tone athletic shoes, leather kneepads, and jerseys with the ace-of-spades logo.

Although no championships are listed, the confident manner displayed by the American Hard Rubber Company's baseball squad in this photograph from the 1920s makes them look like formidable competitors. Though only minutes from Shea Stadium, College Point today is a divided community, harboring fans of both the Yankees and the Mets.

The Vigilantes, shown in this beautiful c. 1925 photograph, were another local amateur baseball team. It is unclear why the name "Marvin" appears on some of the uniforms. Note the very young and sleepy bat boy.

The caption on the back of this 1912 image identifies these fine-looking gentlemen as the "New Year Callers of College Point." They must have spent New Year's Day going from house to house greeting their neighbors in a charming small-town custom similar to that performed by welcome wagons in communities across America.

Five
College Point Life

One of the most striking aspects of life in College Point is the community's autonomy within New York. Even though College Point has some spectacular Manhattan views and aircraft swooping in and out of La Guardia Airport seem always to be in sight, the neighborhood feels as remote from New York's bustle as it does from high-speed travel. The photographs in this chapter show how College Point has always remained a village within the city. We see in this chapter its blacksmiths and ceremonial greeting committees, the long road from the edge of town to the nearest but still distant neighbor. We see the old trolley line that connected College Point with Flushing, the larger town to the south, and the spur of the Northside railroad system that once carried thousands of weekend visitors and still failed to bridge College Point's isolation. Photographs of its main street taken over the decades show different businesses occupying the same interesting old buildings. What is sensed most clearly cannot be seen: College Point's small-town character and its patriotism, even among the immigrants who have always lived there, and the familial and social ties that bind its residents into a cohesive community.

This image, which shows logs supposedly from Abraham Lincoln's birthplace, tells a curious story. The cabin was one of several that appeared in the United States c. the beginning of the 20th century, all falsely represented as the structure in which the 16th president had been born. How this one landed in College Point is uncertain, but c. 1905 it was carefully disassembled and shipped to Kentucky.

This Fourth of July celebration from 1904 is shown from a high perch. The band concert pictured here took place in College Point Park, now called Poppenhusen Park, just off 20th Avenue. The musicians can be seen behind the leftward-draped flag at the center. Also note the parasols carried by many in attendance.

Stile's hotel and saloon, a meeting place and billboard for the Tiger Democratic Club, stood at the northeast corner of College Point Boulevard and 23rd Avenue. The local club's name suggests an affiliation with Tammany Hall, the symbol of which was also a tiger. Democrat Robert Van Wyck was indeed elected mayor in 1897, just before Queens County, including College Point, joined greater New York on January 1, 1898.

Another Independence Day—that of 1917—is captured in this amusing image which shows two members of the College Point chapter of the Aztec Tribe fraternal organization in full regalia. At the right is the entrance to the town train station that stood at the eastern end of 18th Avenue.

The section of College Point Boulevard that runs through the marshland south of 26th Avenue toward Northern Boulevard was once called the Causeway. This unsettling image, shot c. 1935, looks south over the vast stretch of unoccupied real estate through which the Causeway ran.

By the mid-1960s, when this picture was taken, the Causeway had changed its name and sprouted a gas station and a few low buildings. The same section of College Point Boulevard has since been developed as home to a variety of industrial businesses.

This is a closer view of the College Point train station in the photograph at the top of page 23. Originally called the Northside Railroad, train service to the town was discontinued and the station came down in the 1930s. The unusual width of 18th Avenue is a reminder of the ceremonial grandeur of the old gateway into College Point. (Courtesy of Ron Ziel.)

The taxi stand in this superb shot from the 1920s stood at the southwest corner of 15th Avenue and 123rd Street. Note the old gasoline pump at the left.

Laden with local dignitaries, Car No. 1 of the Flushing and College Point Railroad is shown on its maiden run. In the summer, the line was packed with Flushing residents headed for College Point's beaches.

The occasional hurricane is part of College Point's life as a coastal town. A big one on September 21, 1938, did immense damage, as did the storm of September 14, 1944, shown here. Old trees toppled power lines and fell onto homes and cars, as depicted in this image from that day or the next.

This image shows the railway station in the aftermath of the blizzard of March 12–13, 1888, in which 21 inches of snow fell, then drifted in powerful winds, blocking streets, roads, and railways for days.

College Point has experienced some man-made disasters as well. This photograph shows the aftermath of the head-on collision of two trains of the College Point–Whitestone line on September 22, 1913, in which four died.

Looking south from the intersection of 15th Avenue, this c. 1947 photograph shows how much College Point Boulevard, with its light pedestrian and car traffic, resembled the main street of a suburban town.

The Poppenhusen Branch of the New York Public Library on 14th Avenue just off College Point Boulevard was built in 1904 with a grant from Andrew Carnegie on land donated to the city by the community. Recently restored, the small but handsome structure continues to serve its original function.

The movies playing at the College Theater, located on the west side of College Point Boulevard between 15th and 18th Avenues, date this view to 1940. The Atlantic and Pacific Tea Company's market, later called the A & P, occupied the store at the corner of 15th Avenue. (Courtesy of the Queens Borough Public Library, Long Island Division, Illustrations Collection, College Point.)

By the 1960s, when this view was shot from a point several yards south of the one above, the A & P had closed and the College Theater had become a bingo parlor. Yet the streetscape of the boulevard changed little over the intervening two decades.

As in many smaller communities, sitting on the porch and talking was a favorite College Point occupation. The steps on which the people in this fine turn-of-the-20th-century photograph have gathered are those of the 1874 Lebkeuker House at the corner of 18th Avenue and 125th Street.

Though the handsome building is long gone, Otto Muhlenbrink's Turn Hall was a popular hotel, restaurant, and bowling alley that stood at the corner of College Point Boulevard and 15th Avenue. Captured here too is the easy, small-town way of life that allowed two police officers to pass the time chatting with a College Pointer.

Scouts and den mothers and fathers are shown assembling for a parade in front of Kessler's Hardware on College Point Boulevard c. 1950, when venetian blinds cost $2.50 and window shades 98¢. The town is home to one of the oldest Boy Scout troops in the country, chartered in 1910.

Some of the youngest cub scouts in town are shown assembled here, evidently for a parade, on the steps of St. Fidelis in this c. 1960 group photograph.

This c. 1920 postcard view of College Point's first movie theater, the Regents on 13th Street, now College Point Boulevard, repays close inspection. In addition to the magnificent bunting and the interesting, partially visible advertising poster, the people posing in front (dressed with the greatest care) appear to be on holiday, but not, however, the older woman in the doorway at the right.

No photograph in the Poppenhusen Institute's collection is more beautiful than this c. 1910 image of a blacksmith at work in front of his shop on 123rd Street near 14th Avenue. A typewritten caption affixed to the back in 1960 identifies him as "V. S. Krapp, Horseshoer, Blacksmith & Wheelwright." Although Krapp's shop is gone, St. Fidelis, behind, still stands, as does the small house partially shown at the left.

The caption on the back of this photograph says that Katherine Wiesacker Bruehl donned her wedding dress to celebrate the 50th anniversary of her marriage to George Bruehl. The dress is not a traditional gown; brides of limited means in the 1890s often bought a garment that could be worn again. Bruehl's gown appears to have been in superb condition and to have fit her with remarkable ease.

A stern officer Charles Unbekant is captured in this superb portrait. The stripes suggest that he was a sergeant; the emblems on his helmet, badge, and belt buckle are those of a unified, post-1898 New York City police department, helping to confirm the accuracy of the date of "1902 or 1903" written on the back.

Six
SERVING THE COMMUNITY

From the earliest days, College Pointers have served the town and city as police and firemen and the nation as soldiers. Many of the Irish and German immigrants who settled in College Point fought with great distinction in the Civil War. The town was home to three winners of the Congressional Medal of Honor, including Carl Ludwig, shown in photographs on pages 106 and 107. College Point had its own police force until the town merged into Greater New York in 1898. As in most towns, fires were fought by volunteer companies, which also served as men's clubs and marching societies, that had a taste for theatrical uniforms and the pomp of parades. Generations of firefighters have continued to call College Point their home; of the nine College Pointers lost in the September 2001 attack on the World Trade Center, six were members of the New York Fire Department.

Carl Ludwig, shown above, found himself in the Union army only a few months after emigrating to New York from Germany by way of France. Ludwig won the Congressional Medal of Honor, here pinned to his lapel, for bravery in the Battle of Petersburg in June 1864. He was one of three College Pointers on whom the nation's highest military honor was bestowed during the Civil War.

Elderly but vigorous, seven Civil War veterans from College Point sit on the steps of a local restaurant for a patriotic occasion, perhaps the Fourth of July. The town's war heroes assembled regularly for such events, as shown here and in the photograph at the bottom of page 28. Medal of Honor winner Carl Ludwig, seen in the previous photograph, is second from left in the middle row.

The men of College Point fought courageously against Germany in World War I, even though many were the sons of German immigrants. This touching group portrait of local doughboys, many of whom are far from young, captures their brave spirit.

107

The photographic archive of the Poppenhusen Institute is a treasure-trove of superb images of local police and fire companies. This is one of the greatest, showing members of the Eagle Hook and Ladder Company No. 1 in spectacular full-dress attire. The photograph was taken by Jacob Wieners Jr. in the mid-1880s. Founded in 1854, the Eagle was College Point's first organized fire company.

Hardly less splendid is this group portrait (also by Wieners Jr.) of the Union Hose Company No. 1 proudly assembled in front of their first firehouse, which stood on 20th Avenue between 123rd and 124th Streets. The company's magnificent pumpers have also been hauled out for the occasion. The dress worn by the little girl in the front suggests a date several years earlier than that of the photograph at the top of the page.

In a group portrait by Wieners Jr. dated September 2, 1901, the Enterprise Hose Company No. 2 is shown in front of the 14th Road firehouse, variously called "the Barns" and "the Barracks." Founded in 1861, the Enterprise was the third and last volunteer fire company to be organized in College Point; the municipal fire department took over local operations in 1908.

Proud in their uniforms, the Enterprise Hose Company and their pumper and mascot pose in front of "the Barns," in this image that predates the one at the top of the page by 10 or 12 years. Note the brass speaking trumpets, which were used to clear the way for the racing fire wagons.

This 1911 image of Engine Company No. 40 is, remarkably, from a postcard. Written to Master Arthur Miller of 13th Street (now College Point Boulevard), the inscription identifies the fireman standing at the far left of the second row as "Uncle Lou."

The Union Hose Company No. 1 and its mascot pose here for the occasion of the group's golden jubilee on June 8, 1907.

Jacob Wieners Jr. took this group portrait of the members of the 76th Precinct *c.* 1900. Though damaged, this image is still clear enough to identify the mustachioed policeman at the left of the very front row as Charles Unbekant, from the photograph on page 104.

Another brilliant group portrait by Wieners Jr. shows the conductors of the Flushing and College Point trolley line *c.* 1900. The man out of uniform at center and the two little boys are unidentified. These men show the same pride and professional dignity as the firemen and policemen in preceding images.

This unusual round c. 1900 image shows an old firehouse on the east side of 114th Street between 14th Road and 14th Avenue, with Donnelly's Pavilion—the beer garden resort shown in the images on page 72—in the background. Donnelly's is gone, but the firehouse remains, now in use as a private residence and recording studio.

There is much to admire in this striking image from the beginning of the 20th century: police chief Mike Martin's beautiful horse and carriage; the sweet-looking girl with him; and his heroic muttonchop whiskers. The water tower at the right places the scene at 14th Avenue, called High Street when this photograph was shot.

More classically composed but just as beautiful as the preceding photograph of Mike Martin is this picture of an unidentified chief of the College Point Fire Department sitting in his beautiful gig in front of the 126th Street headquarters of the Eagle Hose Company No. 1.

A fire engine, led by a dog and apparently watched by everyone in town, races down a College Point street to a fire. The boys standing on both sides, the father and child in the background, and what looks like a spectator in the second-story window of the house just right of center—even the garbage cans at the bottom—are all so carefully placed that the image looks posed.

113

Also proudly serving the community are the College Point Volunteer Life Guards. Shown from left to right in this virile c. 1925 group portrait are as follows: (front row) "Dutchie" Grell, Fred

Krell, and Lou Emmerich; (middle row) ? Bopp, Capt. Bob Whitten, and Martin "Red" Wild; and (back row) Frank Phillips, Arthur Hunter, Fred Mahler, and Ray Pitt.

Conrad Poppenhusen, the industrialist and great benefactor of College Point, sat for this fine portrait by Hamburg photographer E. Bieber sometime after 1873. Poppenhusen was born in Hamburg in 1818 and died at his College Point home in 1883.

Seven
The Poppenhusen Institute

Conrad Poppenhusen founded the institute that bears his name in April 1868 by donating the site and making an endowment of $100,000, which he soon doubled. With great ceremony, the majestic landmark structure housing the Poppenhusen Association opened on May 7, 1870. Poppenhusen conceived of his institute primarily as a secondary school where boys could take vocational courses and girls could learn homemaking skills, but the building also housed College Point's town offices, a library, a small bank, and the nation's first free kindergarten, then an advanced German educational concept. Equally progressive and characteristic of Poppenhusen was his insistence that the facility be open to people of all races and religions.

Sadly, Poppenhusen's high-minded philanthropy did not keep him from losing most of his fortune a few years later. With dreadful timing, he invested heavily in local railroads just as a wave of consolidation hit the industry in the late 1870s and the U.S. economy went into a deep slump. Additionally, he unwisely entrusted his sons with management responsibility, though none had any experience in the transportation business. Poppenhusen rebuilt part of his fortune before he died suddenly in 1883 in College Point, the American town that he had adopted and transformed.

The Poppenhusen Institute has served College Point as an educational and community center for more than a century, adjusting over decades to the larger needs of the town and American society. English has been taught there to immigrants and welding to women during World War II. In addition to serving as College Point's historical museum and archive, the Poppenhusen Institute offers a variety of workshops, plays, concerts, local functions, and other services to the community. A masterpiece of Victorian style, the building itself has undergone almost no substantive alteration.

The Poppenhusen monument, shown here in a postcard view from the early 20th century, was erected in 1884 in a small park at College Point Boulevard and 12th Avenue: the heart of the community to which he gave so much. The inscription on the pedestal reads, "To the memory of the benefactor of College Point." The park has been cared for by local resident Betty Pagen since 1970.

This group portrait of the Poppenhusen clan from 1870 shows Conrad seated regally at the center with his family arrayed around. Poppenhusen's second wife, Caroline, sits to his right with a baby on her lap; his son Adolph, whose home is shown on page 27, stands directly behind him. Local historian Robert Friedrich suggests that the opening of the Poppenhusen Institute was the occasion for the portrait.

Poppenhusen Institute,

College Point, May 7th, 1870.

ORDER OF EXERCISES:

1. Poppenhusen Institute March, *F. W. Grell.*
 BY THE GOVERNOR'S ISLAND U. S. BAND.
2. Address, *By Conrad Poppenhusen.*
3. Song, "Eine feste Burg ist unser Gott," *Paur.*
 BY THE COLLEGE POINT SINGING SOCIETIES AND BAND.
4. Address, *By J. W. Covert.*
5. Song, "Heil! Heil! Wir sind unsterblich," *Mozart.*
 BY THE LUTHERAN CHOIR.
6. Ouverture "Enchanting Glance" *Lowe.*
 BY THE BAND.
7. Address, in German, *By O. Ottendorfer.*
8. Song, "Die Himmel rühmen des Ewigen Ehren," *Beethoven.*
9. Doxology (Music Old Hundred),
 (BY ALL PRESENT, THE AUDIENCE RISING.)
 Praise God from whom all blessings flow,
 Praise him all creatures here below,
 Praise him above ye heavenly host!
 Praise Father, Son and Holy Ghost.

DOORS OPEN AT 3 O'CLOCK.
Exercises to commence promptly at 3.30 P. M.

☞ Owing to the limited space, no person will be admitted to the ceremony without a ticket, but at 5 o'clock, at the close of the ceremony, the building will be thrown open to the inspection of the public generally, and the Band will continue to play.

This noble document is the program of the opening ceremonies for the institute. In his address, Poppenhusen spoke of "the duties of the employer towards his employees going beyond the mere paying of their wages ... This duty, I thought, could best be fulfilled by giving to your children the means of a better education." Poppenhusen's words ring as true today as they did on May 7, 1870.

The Poppenhusen Institute today possesses the same high Victorian splendor as when this picture was taken from across 14th Road. The structure at the left was the firehouse that is also shown on page 109; the brick house at the right still stands. The presence of these neighboring structures helps to date this image to c. 1920.

The sharp light and air of a winter day c. 1920 allowed an unknown photographer to capture every architectural detail of the institute's front entrance, including the fine, old-fashioned gilt signs advertising the classes offered there.

When Poppenhusen set up the first free kindergarten in the United States at the institute, the concept of a class for very young children was new. This great image, taken in the institute's backyard, shows one of these early kindergarten classes. One can practically hear the teacher telling the kids to be still and look at the camera, but the boy third from the right in the third row has other ideas.

Shot about 30 years after and from a point a few yards east of that of the photograph at the top of the page, this image captures a group of primary students of widely varying ages at play. Note that the boys wear knickers and an older boy and girl wear neckties.

121

Rosie the Riveter was also from College Point, as this great World War II photograph of a Poppenhusen Institute class shows; three of the four women even wear head scarves, just like the symbolic welder of the posters. This picture was taken in the institute's ground floor kindergarten classroom.

Conrad Poppenhusen's wish that the institute's courses offer a practical education was followed for a century, as shown in this 1960s image of a machine shop class. Today, the institute's programs are focused more on youth activities, drug education, musical and theatrical performances, self-improvement workshops, and local history.

Like other Queens neighborhoods, College Point has been the first American home to countless immigrants. This touching image shows 17 of them in an English language and Americanization class at the institute in the 1920s. The ladies at the rear just left of center are identified as instructor Effa Mae Bice (wearing glasses) and secretary to the principal Ruth Braun Henselder.

Charles R. Bostwick, principal of the Poppenhusen Institute, and his secretary are shown at work in his office in this 1928 photograph. The same handsome room continues to function as the office of the institute's director.

123

The Poppenhusen Institute's second-floor Grand Hall may be the least known of New York's magnificent rooms. It is a majestic balconied auditorium that has served over the years as venue for great and small occasions. This brilliant image shows the band that performed at a Saturday night dance held there on November 19, 1924. From left to right, the members are as follows:

Edward Klein, drums; Teddy Schaefer, trombone; George Rausch Jr., cornet; Gus Leifler, saxophone; Everett Casilious, saxophone; unidentified, violin; and Eddie Heckman, who started the band, at the piano.

Taken from the auditorium balcony, this c. 1940 photograph of a formal evening provides some sense of the room's huge scale. The painting is Friedrich Spangenburg's *The Triumph of the American Union*, a grandiose celebration of the end of the Civil War, which hung at the institute from 1870 until 1980. Happily, it was re-donated in 1984 and is displayed once more as shown here.

The Poppenhusen Institute has served College Point in many functions, from bank to government center to school and as the social heart of the community. Here, in a picture shot by local photographer Tony Scatena, residents gathered for its 1965 Christmas party to sing carols in the large ground floor room that originally housed the kindergarten.

Few events at the Poppenhusen could have provided the College Point community with more straightforward pleasure than this clambake celebrating the advent of summer, which was held in the institute's wide, shady yard on June 15, 1968.

Visitors always insist on a very close look at the old jail cells on the institute's ground floor.

Sailing on Flushing Bay, College Point, L. I.

Almost a century has passed since College Point was the subject of picture postcards that highlighted its charms as a waterfront town.